All Blacked Out
& Nowhere To Go

by Bucky Sinister

GORSKY PRESS

LOS ANGELES • CALIFORNIA

2007

Published by
Gorsky Press
P.O. Box 42024
Los Angeles, CA 90042

copyright © Gorsky Press, 2007
all rights reserved

ISBN 0-9753964-6-3

cover photograph
by Anna Brown

cover design
by Sean Carswell

This is for all my boys in BNO.

table of contents

introduction

At the end of *Whiskey & Robots* was a poem called "The House That Punk Built." It was the poem written most recent to the publication of the book. After all those whiskey poems I wanted to leave with a note that I eventually got sober. It's the longest poem in the book, yet it didn't say enough.

Whiskey & Robots was underway, and the new poems started coming. All the memories of the house were in the forefront of my mind. I wrote down every thought or story I remembered about the house I lived in while bottoming out.

There's no way to tell the story in a linear fashion. Every morning I drank a pint of whiskey and every evening I drank another. Most days and nights nothing of importance happened. I watched HBO and drank. What remains in my mind are snapshots of incidents, moments that floated to the top of the swamp of my drunken mind. This is more like a photo album with descriptions of the pictures.

I've often considered storytelling an important part of poetry. This is a series of poems meant to tell a love story. I fell in love with the punk life in the late '80s. By the late '90s I hated it, and now I've come full circle and love it again. Punk gave me a chance to fit in. Unfortunately, I was the sick bastard who treated his loneliness with isolation.

All Blacked Out
& Nowhere to Go

the loudest fastest Abraham Lincoln poem ever

Abraham Lincoln
once walked five miles
to get to a show.

Back then,
Mary Todd
sang for a band
called the Railsplitters.

After the show
he bought a stovepipe hat
from her merch table
just for an excuse to talk to her.

They hit it off immediately.
Soon, they started a band
called Emancipator.

Lester Bangs,
in an article for *Creem* magazine,
wrote that Lincoln was
"a musical and a psychological
frontiersman," and
their album
The Gettysburg Address,
and the single from it,
were the most enormous hits
since the Velvet Underground.

John Wilkes Booth
was a Confederate Skinhead.
He shot Abraham Lincoln
with a round slug .44 derringer
during a show at the Ford Theater.

When asked her thoughts,
Mary Todd said,
the scene isn't as cool as it used to be.

why i left st. louis

I sweated through the work week
waiting for the show on Friday.

The trophy warehouse was always
15 degrees hotter than the rest of St. Louis.

It wasn't the heat
that bothered me,
it was the failure that
hung about the place
like a wet towel on a corpse.

The racial tension was so stiff
the white and black employees
worked in separate halves of the warehouse.

The whites said
the blacks didn't work hard
and the blacks said
the whites' part of the warehouse
was better ventilated.

Truth was:
no one worked hard
and the whole warehouse
was a parked car in hell
with the windows up.

Everyone hated me equally,
since I had had a year of college,
so I was neutral.

The whites sent me to run errands
fetch parts and stock they needed
from the blacks.

Hey college boy,
my white supervisor spat
as he handed me a slip,
Go in the back and fetch this.

I went to the back,
happy to be between hate for a moment.

In the back,
I handed the slip to the black supervisor.
he looked at the note
like it was written in shit.

Say, boy,
he sneered at me,
this marble's gotta be cut.
we don't have this lying around.
why don't you come back later?

That's okay,
I told him,
I can wait.

He disappeared.
I looked at the Post Dispatch
on his desk without picking it up.
He came back.

That's going to be a minute,
he said.
why don't you come back later?

That's okay,
I told him,
I can wait.

You ever fuck a black girl?

At that time,
I had only fucked one girl,
and she was white.

No.

You don't like black girls?
They're not good enough for you?

No, it's not that…

What then?
He pointed to some pictures on his desk.
That's my baby sister.
You don't think she's good enough for you?

She's very good looking…

So now you wanna fuck my sister?
God damn, boy, you got some balls
coming back here to my desk
and saying you wanna fuck my sister.
Maybe I should waltz up to your table
at Shoney's after you get outta church
and tell you I want to fuck your sister.
now what you think about that?

I'll be back for that marble, I said.

I didn't want to go back empty handed.
Instead I went to the aisle
where we kept all the gold trophy men.
no one went back there.

Hay bale sized bags
of little leaguers and bowlers
came in from Taiwan.

Some poor asshole
in Taiwan
had to make trophy parts
for games he may never get to play.

When new bags came in,
I was the poor asshole on this side of the ocean
who sorted the static figures into bins.
I separated out the broken ones
filled a trash can with them.

Limbless and headless
gilded and still
they never had a chance
to be on someone's shelf.

I thought of that guy
in Taiwan,
wondered if he hated his job
as much as I hated mine.
wondered how much time
he spent making the pieces
that broke
just so I could throw them away
halfway around the world.
Wondered what he did after work,
if he went to see bands on the weekend
what music he listened to at night.
We were two assholes
an ocean apart.

After fifteen minutes,
I went to pick up the marble.

Damn boy, where you been?
This marble's been sitting here for ten minutes.

I wheeled the marble back to my supe on a handtruck.

Where the hell you been? he said
Is that what they teach you in college?
How to take your own damn time?

Friday night came around.
Three bands I'd never heard of.
I didn't care.
As long as they were
loud and fast.

There was a problem at load in.
There was a skinhead band
that wasn't supposed to play there anymore.
Every show
they booked themselves
under another name.

There were no
ins and outs.
We waited there
in that deathbox of a club
sweating and looking for an excuse.

The punks and skins got along mostly
but it wasn't looking good right then.

There were others with jobs as bad as mine
or fathers who were worse than our jobs
we all had something to get out
this was a room full of people
with alcoholic fathers
and vacant mothers.

It was not a scene
of political action
or vinyl collectors
as many shows were
that I later saw.

It was a scene
of the leftovers
and the ill minded.
No one wanted us
and that commonality
was all we shared
through the music.

Not all of us got along
even with our friends
and no one liked each other very much.

The band started
before a brawl did
and things looked all right
until the PA blew.

The lights came up.
If the skins couldn't mosh
they were going to fight.

Big Melba started yelling
and trying to start shit with anyone
dumb enough to fuck back.

I was out the front door.
It wasn't quite dark yet
and there wasn't a one of us
who was ready to call it a night.

Lisa was in the parking lot,
getting in her Mustang.

I know where there's a party.
If you want, follow me.
Don't tell the skins.

I followed her the best I could.
I was driving an 85 Ford

that almost rattled out of my hands
if I took it past 65.

That cop waited
till he was damn near in front of me
and hit the lights and the siren at once.

Get out of the vehicle.
Show me your hands.
I said show me your goddamn hands.

The cop walked out
hands on his belt
doing his best Buford Pusser:

Boy do you have an idea of how fast you were going?

I was trying to follow somebody

If you couldn't catch them going that fast
you're either full of shit or stupid
you been drinking boy?

no sir

you been smoking any of that crack?

no sir

you're sweatin like a stuck pig boy
you high?

no sir i was at a concert, it was really hot

I'm going to leave you with a ticket
for an illegal lane change.
how does that sound to you?

that's fair.

One more thing he said,
turning off his flashlight
and stepping a tongue length from me
if my boy came home
with a haircut like that
I'd beat the living hell out of him.
how does that sound to you?

that's fair.

I watched him drive off
I had no idea where the party was
It was completely dark
the night was done.

Monday at work
they put me in the dumpster
breaking down boxes.

The more I broke
the deeper I got
until I couldn't see over the edge

It was just me and the wasps
in that pondwater-green box
but even there
I couldn't find welcome.
It was not my home.
It belonged to the insects
and they didn't want me to stay.

california fucking dreaming

1.

In my parents' house in St. Louis
I dreamed newsprint dreams of California
Not the bikini beach Hollywood Ray Ban dreams
but the *Maximum Rocknroll* Scene Report dreams.

In California
there were good all ages shows
every band I'd ever heard of played there
sometimes they played
in basements
or backyards.

The neighborhood I was in
was a Sargasso Sea
for American muscle cars.
If I broke down and bought a car
I'd never get out.

The suburb was a corpse
and the buzzing hot rods
were a halo of flies.

2.

I gave notice at the trophy factory.
I made $5 an hour before taxes and union dues.

I told them all I was moving to California.
Their response was,
what are you going to do out there?

Find another shitty job like this one,
I told them.

3.

I arrived in LA
in the Days of
of Hair and Spandex
and the punk shows were hard to find.

The shows were expensive
& I was broke.
Everyone went in groups
& I was friendless.
I didn't look right
and I didn't know
the right bands.

People kept telling me
I'd like San Francisco.

4.

I moved to SF
to be close to Gilman Street
which turned out
not to be in SF at all.

Maximum Rocknroll
didn't have a map section.
How was I supposed to know
that Berkeley was not
a neighborhood of San Francisco?

5.

Twelve years later
I woke up to the sound
of bands playing in my backyard.

I was living in Oakland
in a house more popular than myself.

I didn't want the bands playing
but there was no way I was going to tell them to stop.

The House wanted them there
and that's all that mattered.

6.

The House was more popular than any of us.
Punx from all over the Bay Area knew The House,
but few of them knew me.

The House had parties it never invited me to.

One Friday afternoon,
I woke up with my ear on the floor.

I heard the sound of young punx
coming from miles away for the weekend parties.

Every weekend,
the friends of The House showed up,
with pockets of drugs
and armloads of cheap booze.

Every weekend,
they were younger than the weekend before.

They came from all over the bay area
hair burning manic panic bright
armloads of amateur drunk drinks:
coconut rum, flavored vodka,
schnapps, clear malt drinks,
all of it claimed stolen
from supermarkets or asshole fathers.

They partied upstairs on the weekends
trying hard to feign boredom,
attempting to pass for jaded

all the while
betrayed by their own eagerness.

7.

None of the young uns
wanted to talk to me.

I was the ghost of Punk Rock Future:
broke down, fat, old,
& whiskey bloated.

8.

The house leaned to its right ever so slightly
as if it was on a standing nod,
with the balance of a career junkie.

Its features cockeyed, off-level:
door frames and window frames
cross eyed each other.

The front yard was like a sandbox
for the naughtiest children:
forgotten toy 40 ounce bottles
and cigarette butts dotted the lawn.

A passed out Nissan
with no windshield or windows
slept in the driveway.

The cable box
sprouted black licorice vines
that grew up the side of the house.

Three floors
pulsed with activity
of various pace and vice.

On its face
the house displayed the infamous address
that become its name:
666.

9.

The House swallowed me.

In the belly of the beast
was the punk flat that time forgot.

The flat was full
stuff stacked
shit shoved
everywhere

It was past roommates
going back in time
like generations
like a family Bible

a history of a place
by what its people
thought they wanted
never used
and left behind.

There's six kinds of tin foil
from the speed freak vegans

candy looking aquarium rocks
from the anarchists

bag of brown sugar
solidified into a single block

tiny sword toothpicks

bag of bendy straws
coarse black pepper
paper muffin cups

there's jumper cables
under the bathroom sink

I could pour all of it in the tub
throw in live ends of the cables
create an East Bay Punkenstein monster

make a robot roommate
that got bigger each time
i had more trash
skin the gray of American Spirit ashes
whiskey bottle bones
and a brain from the broken radios
never fixed by tweaker repairmen

10.

I got the life
I always wanted.

by then
I didn't want to live anymore.

When I lay back
on the couch
basslines thumping through walls
that were covered in flyers
from bands
I no longer liked

I had nothing
of which to dream.

traingoyles

Our ears still ringing
we board the train.

> *Three bands,*
> *Five dollars.*

We stink
the stink
of parking lot whiskey
of bummed cigarettes
of secondhand sweat.

> *I hear they suck live.*

We are loud
but no one hears us.
We are obvious
but no one sees us.

> *Did the first band go on yet?*

Our hands bear identical stamps.
Our jackets bear paint and patches.

> *Remember when this place was cool?*

We belong to each other.
This car belongs to us.

> *Let's meet up*
> *before the show next week.*

This is why I went:
not for the show,
but for the ride home.

the best band ever

There is a band so good
no one has ever seen them play.

When the band was around
The Scene was much better then.

Their patches adorn the backs of jackets
like missing children's pictures on black clad milk cartons.

The vinyl was stolen.
They never released CDs.
The cassette was eaten by the car.

People much too young
claim to have seen them,
said their older brother took them to CBGB's
when they were 10.

The band broke up,
they died in a tour van,
they got back together as straight edge krishnas,
the drummer got hair extensions and joined Cinderella,
the bass player is a total right wing republican now,
the guitarist got his fingers bit off by a county fair pig.

They got back together
with a guy from the Subhumans
and this other dude named Dave
but they never recorded anything.
The studio burned down while they were in there.

I asked Diamond Dave Whitaker
if he ever saw them

he said,
no,
but they suck live.

anatomy of the pit

1.

The bodies in the pit spin
like stories in the imagination of an old man.

I don't know how to describe the feeling
but I would never use the word *lonely*.

It can exist without any one person
but it stops existing without everyone.

I don't know how to describe the motion
but I would never use the word *dancing*.

2.

That first pit
I felt like I belonged.
Here were people, like me
who had been beaten
until beating didn't hurt anymore.

These bodies
carved on, drawn upon,
with heart shaped bruises
These bodies
treated as targets
and magnets of scorn

I was them
and they were me
and we were no longer
ourselves.

3.

Hold my jacket
is just one way we say
I love you.

We have five other words and phrases for love.
They are:
vinyl
guest list
all ages
play faster
and
this band sucks.

4.

Geodes can form
in any cavity that is buried.

Pits can form
in any show that is crowded.

The interior of most common geodes
contains quartz crystals.

The interior of most common pits
contains young angry people.

The size of the crystals, their form, and shade of color
make each geode unique.

The size of the people, their age, and shades of anger
make each pit unique.

Geode slices are sometimes dyed with artificial colors,
as are often the people who make up the pit.

5.

New Year's Eve, 1988
Bernard's Pub:

It was snowing so hard
few showed up to the club:
just me and thirty skinheads.

I went there not to see the show
but to see Lisa Cyrus
the most beautiful girl in St. Louis
but she wasn't there.

The skins formed a pit
but the band wouldn't play fast enough,
they were some new wave disaster.

The skins didn't care.
They swirled in galactic spiral arms,
a universe of Docs, white T shirts, and red braces.
I picked out one freshly shaven head
gleaming North Star bright
and wished on it
for Lisa to come.

About eleven, she showed up.

It had been several months.
I had moved to LA,
was back for Christmas.

Face to face with her
I forgot every word I planned out.

There was an awkward lull.
I blurted out,
this band sucks.

She pulled me
close to her
by the lapels of my leather
and kissed in the new year.

Around us
the skins moshed to music
only they could hear.

Outside
it continued to snow.

It was a hell of a way
to start 1989.

6.

While opening for *7 Seconds*
with his band
Unified Field Theory,
Nikola Tesla formed the first pit ever
in Los Alamos, New Mexico.

Albert Einstein denied its existence,
but Neils Bohr claimed to have predicted them.

7.

It's been a long time
since I've been in a pit.

My bruises disappeared
like forgotten stories.

It looks more like dancing now,
it seems a lot more lonely.

But maybe it's just
this old man's imagination.

filler

There are holes inside us
where hope used to be,
where we hid dreams
from those who would take them.

I sat on the floor
listening to Minor Threat
on a struggling cassette player.

I carried the music with me
like a secret heartbeat.

living at the movies

1.

There was one copy
of *Decline of Western Civilization*
in the entire St. Louis Area.

It had been played so many times
you couldn't watch it anymore.

Here's a secret
that you can't tell anyone:
I never saw it.
Though I said many times I had.
I mean, who hasn't seen it?

2.

I know someone
who is in
Another State of Mind.

I was so jealous
when I saw her
all early '80s.

It was 1990 or so.
I felt like I had missed everything.

3.

How many times
have I seen *Suburbia?*

So many times
that I learned to walk

in slow motion.

So many times
I aspired to be a skinhead
who only had two shirts.

Guess what?
Chicken Butt.

4.

Back then,
we didn't have the term
Mallpunk.

Back then
we said
Quincy Punk.

No one remembers
the show *Quincy*.

5.

Halfway through *Lost Boys*,
I leaned over to Lisa.

Are they supposed to be punks?
I whispered.

I'm not sure, she said,
*I think they're supposed to be
really bad rockers.*

I think they're supposed to be punks,
I said.

*Then they're even worse than vampires,
they're POSEURS.*

6.

The year I lived in LA
I tried to be an extra
in the Punk Scene
of a movie.

I thought it would impress
Lisa back in St. Louis.

She already liked me,
but I was a little backward like that.

In the movie *Pale Blood*
a bad vampire film,
you can see me for two seconds
while Agent Orange plays.
The movie never hit the theater.

I found a copy on video
in 1992, but never saw or heard
from Lisa since.

7.

Q:
If Russell Crowe from
Romper Stomper
and Edward Norton from
American History X
got into a fight,
who would win?

A:
The Turnbull AC's from
The Warriors
would stomp them both.

8.

The first time I saw *Repo Man*
I was still a square.

Fifteen years later,
I woke up to the sound of a band
playing in my back yard.

The thought that came to mind:
I can't believe
I used to like these guys.

9.

Sid & Nancy
played on a double bill with
The Great Rock and Roll Swindle
at a theater on Market Street
down by the strip clubs.

It was 1989
but you could still smoke
in the balcony.

I went up there
but these guys got mad.
They had crack.

They said I was an asshole
because I didn't want any
so I left.

Downstairs
a hooker offered
her services:
a date for the movies.
I told her no.
She called me a faggot.

The guy in front of me
told her to keep it down
people were sleeping.

The movies themselves
were suddenly boring.

white devil?

1.

In every ethnic neighborhood,
there's one house of white kids
who can't keep their shit together.

This was that house.

Our neighborhood was all black
except for the 9 of us who lived in that house
and the fluctuating population
that seemed to live there.

2.

Tyler, a black man from the neighborhood
brought a scared looking
black man with him to our house.

We were on the front steps
drinking and smoking.

As Tyler gets closer
we see his scared friend is Muslim.

These people? he says, pointing at us.

Yes, his friend reluctantly agrees.

They can't keep down a job, he says.
How the hell you say they keeping us down?

little monster poems

1.

Little Monster
was my nineteen year old roommate
who went through books
like they were little baggies of speed.
She went through little baggies of speed
liesurely like a good book.

She drank coffee at night
and vodka in the morning.

2.

Little Monster had a horny boyfriend
and a broken futon frame.

With every sexual thrust,
the futon frame gave a thump on the wooden floor.

I came home to a wood on wood tattoo
of lovetapping rhythms.

I imagined it to be a kind of morse code.

tapapapapapapa
hey bucky, could you feed the cats for me?

thumpathumpatapitathumpa
hey bucky, do you have money for the power bill?

When they were done,
Little Monster made Horny
get her deep fried vegetables from Barney's.

She rarely ate anything else
due to her Absolut and Meth diet.
I wasn't much better,
filling up on 3000 plus whiskey calories a day.

While Horny was gone,
she gave me the recap.

His dick is tiny, she said.
but it's sooo good.

This movie is great,
there's lots of car chases
and no oversharing of personal information.

It hits that right spot, she said,
you know, he's got that stroke down.

Horny came back with the food.
Batter fried mushrooms, zucchini, and onion rings,
with ranch dip.
A half pound burger with cheese and bacon for me,
Portabello mushroom burger for him.

I quit eating meat, he said,
It's just so bad for you.

3.

Little Monster called from NYC.

The boys here are really into their arms, she said.
They wear wifebeaters or cut their sleeves off.
They all lift weights but only for their arms.

Are you terrorizing any of them?

Just one, she said.
I liked him because he was a 17 year old virgin.

Acted like a real stud but I could tell.
I was going to fuck him
until he told everyone we already had.
So I took him out one night
way out upstate,
in the woods,
and fucked him in the car.
Then, when he got out to pee,
I took off
left him there,
without his pants,
his shoes, his wallet,
and went back to the city.
I don't know how he got back,
but he was too scared to make eye contact after that.

Why did you fuck him, I asked.

Just dumping him out there
would have been bad,
but I wanted to take him really
high so it hurt when he hit bottom.

4.

It's me, she says.
I don't recognize the number
but the voice is unmistakable.

Her voice is
a cop's flashlight
in a sleeping bum's face.

Where are you? I ask,
Is this your new number?

No, she says,
it's my grandma's.
What are you doing?

I could tell her the truth,
that I've been home from work
for an hour and a half
and I've masturbated twice
into a stolen towel.
Instead I use the alibi:
eh, I'm getting some laundry together.

I have a belly full of bacon, she says,
I had to unbutton my pants all the way.

Sounds good, I say.

Usually I just undo the first button, she says,
but this time I had to go all the way.
When are we hanging out this weekend?

Sunday is bad, I say. So is Saturday night.
I have a date with that girl with the glass eye
I was telling you about before.

I can't believe you made plans, she said,
You didn't leave any time for me.
Why don't you call me at my other number
when you're not being a dick?

I set the phone down
on the undone laundry
careful to avoid the cummy towel.

Does Greyhound require ID? I hear her ask.

I pick up the phone.
I don't think so, I said.

Good, she says,
because I lost my wallet again,
and I think someone

is trying to kill me,
so I'm going to Minneapolis,
or Seattle.

That sounds good,
I said. No one's going to go to Minneapolis after you,
even if they want to kill you.

*I need to throw up,*she says
I don't know if I can,
but I'm going to try.

I was naked underneath the sheets,
watching James Caan in *The Gambler*.
I had the sound down,
the English subtitles on,
the lights were off.
I set the phone down and let her talk.
Good ol' Jimmy Caan.

39th Street Haiku:

On child's dirtbike
he wobbles home on hot night
balancing six pack.

a Sunday like most others

I ran dry
right after *The Sopranos*.

I knew they would have some upstairs
that was left behind from the weekend's party.

I ran out of booze down there,
I said while letting myself in.

Ghetto Chef, Roxie, and The Dink
were doing lines off the glass top coffee table
while watching *Saturday Night Live* reruns on cable

Go ahead, G Chef droned,
help yourself to anything over there.

Trash bags of cans and bottles slept
in the corners of the kitchen
like well fed hoboes.

I looked around.

It was a buffet of booze
only a teenager would love:
Alize, Smirnoff Ice, Peppermint Schnapps.
Booze too bad to finish,
too bad to take home.

From the back of the fridge,
I pulled out a bottle of coconut rum.

You're going to drink that? I heard Blondie say.

I turned around.

She was coming home from somewhere.

Yeah, I'm out of bourbon down there, I said,
I have some cokes to mix it with.

Bring the cokes up, she said
I have some Stoli in the freezer
hidden under the peas and mixed vegetables.

Vodka & Coke is a drink
you should never order in a bar,
but it's damn tasty
if the Stoli is
straight from the freezer,
and you pour it over ice.
The Coke sits on the top,
you drink it without stirring it.

So I got the Cokes, came back,
and we made some drinks.

Adam Sandler and Alec Baldwin
shared a scene on the TV
a boy scout and his troop leader.

The Liners sat around,
in this three day cocaine and PBR
upright coma.
Their brains were life-sucked,
the cocaine, at that point,
was only staving off a hard crash.

Blondie acted like they weren't there
the TV wasn't on, just the two of us
and the drinks.

God, I love these, she said,
but the whole rest of the house
besides you is a cheap beer house.

I can't drink that shit anymore.
I drink the good beer,
but that cheap beer,
It's like drinking piss,
and believe me, I've drank piss before,
real piss, I'm not just saying that.
I didn't drink it on purpose,
it was back when I was a junky,
my fucking idiot boyfriend had this
thing for pissing in bottles,
I think you can see where this is going,
he pissed in this forty bottle
I was on the nod,
started drinking out of it.
It was this really great smack, you know,
I was coming off this long dry run,
it was nice, and then he's like,
do we have any beer,
and I'm like, you can have some of mine,
and he's like, no thanks,
you're not drinking beer,
you're drinking my piss.
I'm all, what? what the fuck?
why did you let me drink your piss, asshole,
and he's all
I thought it was your way
of saying you loved me.
Fucker. I think there was a little beer
still in there, but since then,
beer always tastes like piss.

The vodka hit me nicely
but we ran out of that soon.

Blondie went to her room and crashed.

I tried to watch TV for a while.
It was worse than not funny.
Not even the people on drugs were laughing.

I looked down at my empty glass.
Cocaine was permanently
etched into the scratched surface of the table.
Beyond that,
my sneakers, broken in like a baseball glove,
were like leather slippers.
I remember when I got them,
back when I had a job,
on my lunch break.
I wore them out of the store,
and threw away the old pair
that didn't look this bad.
I no longer had that job
or room left on the credit card I bought them with,
but I still had the shoes.

I'm going downstairs,
I announced.
Should I take down a bag of those bottles?

No, mumbled The Dink.
There's this Krusty recycling gang coming for them.

Of course, I said.

I went back downstairs.
I drank that Parrot Bay rum.
Oh, that was a bad end
to a good night.

It was a Sunday like most others.

the day the cable went out

I stood staring at the TV snow
like it was a tombstone.

Nodout Boy climbed through the house
and restole the cable.

That black line
was the spinal cord of the house.

The cable company
sent a guy
who turned it off.

Nodout Boy,
like a defiant monkey,
stole it once more.

The cable company
sent a different guy.

Look, he said
We know what's going on.
You need to pay something.
One flat, one account
split it all you want after that.

We bargained back and forth
until we got HBO as well.

But before Nodout Boy moved out
he ran up $200 in pay-per-porn
and we never paid the bill.

james beam

A new corner store opened.
Middle Eastern guys,
real eager to make a buck.

They must've gotten really good deal
on this place, it was torn up,
burnt out, and trashed.

It was a half block from my house.

To my abject horror,
they carried no bourbon.

You guys need bourbon, I said.

We have Jack Daniel's, they replied.

I see that, but it's a Tennessee Whiskey, I told them.
It's different.

We don't drink, they said.
We don't know the difference.

Yes, well, get some Jim Beam, I said,
I guarantee you, you'll sell it.

A few days later, they had a shipment.

We have your James Beam, they said.

They had a rack of half pints.

Great, I said,
Give me four.

Four or five days later I returned.

We are out of Jim Beam, they said.

See, I said,
I told you that it was popular.

They laughed.

It was only you who bought it.

how to put on an east bay punk show

The venue
should not be in any public setting
or place of business.

Make no flyers.
If you don't know about it,
you can't come.

When talking about band members
refer to them by first name only.

Dancing is to be done
with the head only.

Watch no more than one band.
The rest of the time
is for smoking outside.

how to put on an east bay funeral

Funerals are the opposite
of Gilman shows;
you must not miss them.

Friends of the deceased sit on one side.
Friends of the drug sit on the other.

Shake hands with your exes.
One arm hug those currently sleeping with your exes.
Bear hug those to whom you owe money.

While the roommates
and best friends
mumble the notebook paper eulogies,
play six degrees of fornication.
Anyone beyond three degrees is fair game.

Warning:
if you funeral fuck the same person
at consecutive funerals,
you must get married.

the true importance of punks versus elephants

1.

Like an elephant
going to its secret graveyard

I had returned home
to the East Bay.

I no longer cared about
shows, records, or anyone else.

I wanted a place to drink
a room to spin me to sleep at night.

I wanted a place to lie down
and die with dignity.

2.

The elephant graveyard
however,
is a myth.

Story goes
that elephants have an internal clock
that tells them exactly
when they will die.

When it's near time
an elephant heads to a secret spot in the jungle
lies down
and dies peacefully.

European explorers

wanted to find these spots
as there would be generations of ivory
in one area.
It was the Big Score.

The reality of elephant death:
It's brutal, sad, and often tragic.

3.

Q: How do you tell when there's an elephant in the pit?
A: Peanut shells on the floor.

4.

Other people
make dying look easy.

They drink
they shoot dope
they cross the street
and it just happens.

They don't try
they don't work at it
they just do it
effortlessly.

They don't even want it.
They get it, while they're young
while badly aging alcoholics
look on with jealousy.

5.

We have the word Jumbo
because of the elephant.

Jumbo was so big
he had to have a special
freight train car made for him.

In those days
they walked the elephants
tail-in-trunk
to the fairgrounds.
This they did
in the dead of night
so the townspeople
couldn't get a free look.
Jumbo was across the track
when another train came along
and took him down.

If there's a metaphor for
a train crashing into the side of an elephant
I don't know what it is.

6.

Q: How do you tell an elephant is a nazi?
A: White laces in his Docs.

7.

Whiskey wanted me dead,
and that's who I took orders from.

I wanted to be a story:
The Guy Who Died
In The House That Punk Built.

I wanted to be told
in a quiet whisper
like the story
What Sammy Did.

I wanted to stun
with frozen disbelief
like the story
Jerme and the Baby Corpse.

I wanted to elicit laughter
like the story
Pranks We Pulled On Hef.

Whiskey,
like a trickster monkey
told me
I would be a story
that has more endings than any other,
that my story would be told
in the backs of vans on long tours,
that broke people on first dates
on the long walk to the show
would tell my story to kill awkward silences.

The irony is
I wanted to be immortal,
I just didn't want to live anymore.

8.

Story goes that
no one in the circus
trusted Big Charley,
the bull elephant
of the Laperl Circus

Only one human,
his trainer,
Henry Huffman,
could get near him.

Henry Huffman
got sick for three weeks.

No one else dared
bathe Big Charley in his absence.

On Henry's first day back
he led Big Charley
to the Wabash River for his bath.

Big Charley,
driven mad by neglect,
grabbed Henry Huffman
and smashed his brains out
against a log dock.
Then, it is said,
Big Charley held Henry's body
under water to make sure he was dead.

Big Charley was shot
shortly thereafter.

His tusks
are all that remains.
On display at the Miami County Museum.

9.

Q: How do you tell when an elephant's been doing your drugs?
A: Trunkprints in the cocaine.

10.

Dead men tell no tales
and elephants never forget.

I left whiskey behind
like it was a piece of shit town
full of rubes.

11.

Old Bet
was bought at a cattle auction
by a Hachalia Bailey, a farmer in 1808.

Old Bet
was auctioned as
three tons of meat.

The farmer took Old Bet
back to the farm to live out her life.
First the neighbors
then strangers
came to take a look.

The farmer realized
there was more money
in elephant shows than farming
and took Old Bet on the road.

Outside Alfred, Maine,
a man who thought it was sinful
to be entertained on a Sunday
shot and killed Old Bet
on July 24, 1816.

12.

Q: How do you tell when elephants have been crashing at the
 squat?
A: All the crusties are smashed flat.

13.

To quit whiskey,
I went to little rooms
where people told me stories.

14.

Hachaliah Bailey tried again.
He imported Little Bett
with the money he had made
from Old Bet.

Little Bett
was the first performing elephant
in the United States.

She took commands,
could balance on either set of legs.

But Bailey made the mistake
of saying her hide was so thick
she was bullet proof.

Some local residents
of Capachet, Rhode Island,
decided to test the theory.
Some say there were five gunmen,
Some say there were seven,
But the fact is
one bullet went through her eye
and she dropped dead on the spot.

15.

Q: What's the difference between a tweaker and an elephant?
A: The elephant will eat all your peanut butter.

16.

I am not a story
nor will I ever be one.

I live to hear them
and tell them

alter them make them

take them across the country
and show them to everyone
stories as powerful and mysterious
as a beast
from a foreign land
stories as shocking as
the freakshow geeks
I am not the story
just the barker.

17.

Black Diamond
was such a scary bull
they cut his tusks down
and put a bar across them
to limit the use of his trunk.

When they led him off a train,
they kept him chained
between two docile
female elephants.

October 12, 1929
was a beautiful day
in Corsicana, Texas.

The train was late,
and the animals
had to be led to the grounds
in broad daylight.

Eva Speed Donahoo,
like many other townspeople,
came out to watch the procession.

She came with her
plantation manager,
Curley Pritchett,
whom she had hired away from
the world of elephant training.

Black Diamond saw his estranged friend,
pulled Curley to him,
and, to some accounts,
shed a tear on his head.

Upon releasing Curley,
Black Diamond grabbed for Eva Speed.
He knocked her about with his trunk.
While others tried to subdue him
and chain a third elephant to him,
Black Diamond attacked Eva Speed
until she was dead.

The Ringling Brothers
who were days away
from buying the circus
wanted to kill Black Diamond.

It was suggested
to dump him in the Gulf of Mexico
to drown, with casts of lead upon his feet.

It was suggested
to make nooses of chains
attached to other elephants
to strangle him.

1200 grains of cyanide
tainted oranges, his favorite food,
but he wouldn't touch them.

Finally,
they led him outside town

chained him between three Mesquite trees
and shot him 170 times.

Two weeks later,
the stock market crashed
in what was known as
Black Monday.

18.

Q: Why don't elephants go to straight edge shows?
A: They don't like getting their beers slapped out of their
trunk.

19.

I live to tell stories
and that is the way stories live.

Stories only die
when there is no one left to tell them
when they cannot grow and change
in the mind

When I die
I will no longer tell any stories.
Until then

I will tell to those who will listen
any story I can remember
about angels with clipped wings
ships made of dreams that sink in oceans of whiskey,
about heartbreak cigarettes
brokedown saints
and how elephants really die.

20.

Big Mary

was five tons of pachyderm
with rumors of the same size.
Some said she had killed 8,
others said she had killed 18.
But these were rumors
and the truth was
she could play 25 songs on horns
and hit baseballs with a bat held in her trunk.

Red Eldridge
a drifter
left his job as a hotel janitor
and followed the circus
as an elephant trainer.

Red was fearless
and the other carnies
were suspicious of Big Mary,
so they let him tend her.

This is where the story splits three ways:

Some say Big Mary
stepped on Red's head
Some say Big Mary
gored him and tossed the body into a crowd
Some say Red Eldridge
hit Big Mary with a stick.

But in the end Big Mary
had killed a man in public
and no one wanted a circus
with a five ton killer in town.

Like other killers in that town
they decided to hang her high.

They hanged Big Mary from a crane
They had to hang her twice

she was so heavy she broke the first chain

5000 people came out to watch her die.
They called her Murderous Mary.
Later when they were taking out her ivory
they found out she had an nasty abscess
right where Red Eldridge hit her.
I would've stepped on his head, too.

21.

Q: How do you tell when an elephant's been reading
Maximum Rocknroll?
A: Newsprint on his trunk.

22.

When I die
I will leave behind
only
one Bustelo can of ash
and many stories
stacked proudly as bones
in an elephant graveyard
and just as mythical.

how the house died

The bank took it from the landlord.

And sent a contractor,
like an exorcist,
who gutted all the demons
out of the walls, floors and foundation.

I drove by The House once.
It no longer leaned,
there were new window frames,
and the numbers had been taken from the front.

The House was ugly

but it was all I had of home
and all I needed of hell.

elegy for the old hunt's

1.

There's a legend in the Mission:
If you write your wishes
really small on a piece of paper,
and stick it into a fresh bullethole,
all your dreams will come true.

2.

There's a hole on Mission Street
where the donut shop used to be.

The sign outside said ,
Open 25 Hours.

The sign inside said,
*These premises are not to be used
for the buying or selling of
stolen merchandise.*

Any time of the day or night
one could buy
gold chains, bear claws,
bicycle seats, éclairs,
DVDs, chocolate covered old fashioneds,
CDs, buttermilk bars.

Outside,
old men shot craps,
crackhead magpies
exchanged shiny treasure
for dollar bills,
and young men
tried to look older.

3.

She stole my heart,
he told me,
and nine months later,
she stole the rest of my shit.

I came home,
and the place was empty,
she took everything,
even the food.

I took a look for my stash:
still there.
I rolled me a joint the size of your pinky
and shortly thereafter
I came down here
for some snacks.

I picked out a bear claw
when I spotted my
eight track on the table by the window.
That was Slow Charlie selling my shit.
Now they called him Slow Charlie
on account of the way he talked,
not on account of the way he used a razor.
I knew not to push it,
that I had to shut up and buy it all back.

I bought back
my eight track
my hi fi
my rekkid player
my color TV and the clicker
my Power Man comics
my Iceberg Slim novels

and then would you believe it,
I saw my own motherfuckin heart

lying there on the formica.

I said, Slow Charlie,
now I'm cool buyin this shit back
but you got to cut me a break
on this here heart now baby.
I can't pay you full price
cuz I know for a fact
this heart is broke AND stolen.

Slow Charlie
takes his damn time
his mouth moving slower
than Christmas on a leap year.

He said,
say you got a heart that ain't been broke
I'll tell you to go to hell.
Say you got a heart that ain't been stole
and I'll steal that shit myself.

I said, Say, now, Slow Charlie.
Don't give me that
street rap it's-true-because-it-rhymes
bullshit.

Then I saw his fingers twitchin
like they did that night in Nap's Bar
and I said,
It's cool baby, it's cool.

But I was out of cash.
I had to go home.

I put the bear claw
in the hole where my heart should be

but that night
every time I thought of her

I gained four ounces.

4.

That first month I was sober
I'd wake up
like a sandbag was dropped on my gut.

All I could think
was
whiskeywhiskeywhiskey.

It was the liquor store
or the donut shop.

The donut shop was on the way
to the liquor store
and it always stopped me.

5.

In the 25th hour,
If you looked through
a donut hole
out the window
you could see across
space and time.

One night I was there .

I stared out the window
at Mission Street.

I saw GI's in the '40s
cruising the miracle mile
under the theater lights.

I saw lowriders from the '70s
bumper to bumper.

I saw myself from 1989
walking right by
I banged on the window
started yelling out
bet on the A's in four,
buy Microsoft and Wal Mart,
and
hey, dumbass
she's right in front of you.
Don't think too hard
let it happen.

Right as '89 me turned around
and mouthed "*what?*"

The 25th hour was up.

6.

When there was no more room in hell,
the dead came to Hunt's.

The junkies with a sugar jones.
The young vatos looking for a break.
The heartbroke drunks from the bars.
Iggy and Ivy doing midnight homework.

There were cops and crackheads,
yuppies and bums,
the cool, the trendy,
and the clueless.

All of us
needed a donut
sometimes.

The night they gutted Hunt's
I stood outside the gaping hole,

thinking:
Where will we go?

7.

There's a hole in my heart
where the donut shop used to be.

Hunt's was a place
where it was socially acceptable
to cry at 4 AM.

No one ever asked me
what was wrong.

There were clubs I couldn't stand,
bars where I didn't fit in,
cafes that weren't right for me,
but at Hunt's,
I always fit in.

8.

I had this dream
that all my ex girlfriends formed a gang
and did a drive by on me
as I was leaving the donut shop.

The last thing I did before I woke up
was write this poem really small on a piece of paper
and stick it in my bullethole
where my heart used to be.

epilogue

My father calls
the first thing we talk about is Albert Pujols,
how the Cards almost blew it at the end today.

After that
he tells me he's sick.
His heart's going out

There's a pause.

He was my age
the first time he took me to Busch Stadium.

I want to tell him
I just passed four years sober,
that I woke up this morning
and my head didn't hurt
and it still surprises me sometimes.

I would probably end up telling him
about bottoming out
in a house full of punks.
It's not anything he wants or needs to hear.

It's been over ten years since mom died
but I still have to stop myself
from asking him to put her on.

I don't know what to say
that the gang fights around here
 have calmed down,
that this guy from my 12 step group
 told me last week
he once fixed with his own urine .

I want to talk to him
the way we talked
about Lou Brock,
Ozzie Smith,
Joaquin Andujar,
and Bruce Sutter.

We went through so much together
but when the world stopped attacking us
we turned on each other.

We first became friends over baseball.
When I talked to him
about boxscores and the day's pitchers
he turned into a different guy.

Over the years, we went to
Fenway Park,
The Astrodome,
Texas Stadium,
Argonaut Stadium in Toronto.
We listened to ballgames on the radio.
When I think of summer
I still think of Jack Buck's voice.

The last summer I lived with him
we didn't go to a single game together.

There were two attempts to get me clean.
I tried to convince him the second time worked
and stopped talking to him much.
There's no anger anymore,
but nothing's the same either.

There's a new stadium in St. Louis
we may never go to together.

I've watched guys break in to the big leagues
who are now coaches.

I don't remember the names of our old neighbors
but I remember the day Ted Simmons
was traded to the Brewers
and I feel sick like that again.

This pause
is a problem with two ends.

That Isringhausen,
he says,
he sure makes things interesting,
doesn't he?

Whiskey & Robots

Drowning on God's Urine

And the Lord said unto Cain,
Cursed ye be
for ye hath made the ground
drink of the blood of thy brother
spilt by your own hand.
A fugitive and a vagabond ye shall be
all thy days.

And Cain did reply,
Lord, this burden is too much for me to bear.

Whenceforth did the Lord
unzip his holy pants
and pee into a bottle.
When the bottle was filled
with holy golden liquid
he gave it unto Cain
and said,
Cain, this is bourbon whiskey.
Drink of it when you can no longer bear your burden.

I am an organic robot
driven by a tiny driver inside me.

The tiny driver keeps me awake at night
on long crying jags
and complains
about the undeserved amount of disrespect he receives.

I pour booze on him
in a feeble attempt to shut him up.

If you are a bad child in Japan
on Christmas Day all you get

is a twenty-four inch replica of me
during an alcoholic blackout.

The toy of me
does not run on batteries or solar power
but on lunar power
at night it turns itself on
and won't stop talking.
It knows a lot
but remembers nothing.

The toy of me is
the second least popular robot toy in Japan.
The least popular robot toy
has a name that translates to
"The Low Self Esteemed Robot Turkey
Who Needs Lots of Hugs
and Whose Feathers Are Made from
Jagged Metal Bits."

In the anime cartoon
that was made to promote
slumping sales of both toys
both the turkey and I die at the end
when we catch god pissing whiskey from the sky,
can't stop from looking up,
and we both drown.

The Other Universe of Bruce Wayne

There's an alternate universe
in which Bruce Wayne is poor
and I have my shit together.

Without money,
there's no Batman;
no Batmobile,
no Batcave,
no utility belts,
much less a cool butler and a trusted sidekick.
Without Batman,
there's no crimefighting,
no hot vigilante action,
no pensive brooding on the rooftops of Gotham.
In this universe,
Bruce Wayne drinks alone
in his trailer home in Arkansas.

Bruce has one friend: me.
He calls me in the middle of the night.

"Hey, it's Bruce.
Can you come get me?
I'm feeling real low."

I can tell by the sound of his voice
that he's been dumped again.
In this universe,
Bruce Wayne ain't that lucky in love.

I pull up outside his trailer
in my convertible '63 Lincoln Continental.
Bruce makes his way inside the car,
reeking of whiskey and cigarettes.

"She's gone," he says.
"Can you stop by the store?"

When we get to the store, Bruce hobbles in.
His knees and feet have seen better days.
He's got a couple of vertebrae in his lower back
that cracked and healed poorly that gives him constant pain.
He has chronic headaches
that the VA hospital won't do anything about,
they say it's psychosomatic.

I buy Bruce another bottle of whiskey
and go back to my place.
I know that he doesn't want to talk.
He just doesn't want to be alone.
I turn on the TV and we watch as he drinks.
We watch The Tonight Show with Lenny Bruce.
Tonight's guest is Jimi Hendrix.
He's plugging the album he just cut with Miles Davis:
The Kind of Blue Haze Experience.

He's asleep by the time Late Night with Bill Hicks comes on.
During the guest bit
when Richard Pryor's talking about the cure for Multiple
Sclerosis
I hear Bruce talking, unawake, but not rested.
Bruce talks in his sleep
and I would let him
but when he starts screaming
it's not fucking right, it's not fucking right, it's not fucking right,
I have to wake him.

When he finally realizes he's awake,
he instinctively moves for the whiskey.
He's shaking so hard he can't pour it,
so he drinks it right out of the bottle.
I sit next to him and hold him close to me.

"It's okay, Bruce," I reassure him,
"There's another universe out there
in which everyone loves you.
Children read about you in comic books,
adults make movies about you,
and you symbolize justice in human form."

Bruce exhales loudly and looks up.

"And this in this other universe," he asks, "What are you?"

"Bruce," I say,
"Don't you concern yourself
with that."

Saved

What I remember most
about traveling through the South
with my father when I was a child is
how hard it was to sleep in those cheap hotels
on the unbearable summer nights.

The air conditioners never worked,
just dripped slow
like a diseased metal sore in the window,
rattled like snoring guard dogs.

I'd lie there on top of the sheet
the bedspread kicked to the floor,
trying to kill the one mosquito
that always hid until lights out.

Outside
I could hear drunk adults
fumbling around with the ice machine
and yelling at each other.
Sometimes I'd get out of bed and
spy on them through the window.
I'd wait until no one was around
and my dad started to snore,
then I'd sneak out and get a cup full of ice cubes
to suck on until I fell asleep.

During the days Dad drove with very few stops.
He fancied himself a CB radio expert
made small talk with the truckers and other CB fans.
We listened to baseball games on the AM radio,
and mostly gospel music on the eight track
with a little bluegrass thrown in.

When my father came to town
people came from all over the county to hear him preach.
They crowded up those little country churches
sitting on the floor
standing in the back
outside the cars were packed in so tight
only mangy yellow mutt stray dogs could get through the
parking lot.

The nights were hot and humid
and inside those masonry block walls
the crowd sat quietly, slowly baking.

When he was done the church sang the invitation song
When they sang
earnestly tenderly Jesus is calling
I felt the people tremble

When they sang
ye who are weary come home
I felt the first tears come

and when they sang
calling poor sinner come home
I felt the crowd break like a Mississippi levee.

I asked my father why so many people came
and he said a lot of people need to be saved.

But they came to see him
for the same reason
they went to hookers in Memphis
and strippers in New Orleans and
why they did 130 mph in Camaros on dirt roads and
shot heroin in Dallas and smoked crack in Little Rock
shot craps in Biloxi and ordered useless shit off the TV:
cause they wanted to be saved,

and they didn't know where the saving was,
and tried anywhere they could.

It wasn't the saving they really wanted
it was always something else they could never have

The woman whose husband backed over their kid:
she wants him to stop drinking to kill the guilt

The man whose brother was gored by a bull:
he wants to be able to pay the quarter million dollar hospital
bill.

The Viet Nam vet :
he just wants someone to kiss
the unhealable wound he uses for a face.

I've seen thalidomide kids,
agent orange babies,
and farmers mangled by their own equipment
limbless and struggling to the front
for one little sweatdrop of god's grace,
for one crumb of his infinite mercy to fall from his table,
for one quick grasp to abraham's bosom,
for the relief promised to lepers, prostitutes, and beggars in
the parables of christ

and still I've never seen one of them saved.

As we pulled out of the parking lot,
the gravel rained up in our wheel wells.

They waved, wore unsure smiles;

from the back window, as they got smaller,
they looked like they were on an island forgotten by God.

Later that night
they wouldn't feel so saved anymore

and they would try anything again
they would drink whiskey from mason jars
give money to strangers on the tv
shoot out windows
hang themselves in barns
but nothing ever worked

As my father and I rolled on to the next town
The CB radio crackled trucker's hopes and dreams
bugs kamikazed themselves on the windshield
my legs stuck the vinyl seats
and the nights now
are never as hot
as they were then

The Day the Angels Died

The day the angels died
you called and woke me up.
Call in sick, you said,
we're spending the day together.

You showed up at my house with two coffees and a couple of
trash bags.

This one's yours, you said, iced coffee, black, no sugar. This
bag is yours, too, we're going to the beach.

On the bus ride there, we saw all the angel bodies stuck in
trees, tangled in power lines and sprawled on rooftops. When
we saw one impaled on a church spire, you said, that's
symbolic of something. I laughed so hard I thought coffee
would come out my nose.

The beach was littered with angel corpses that had washed up
from the sea.

What are we doing? I asked.

Collecting halos, DUH.

I tried pulling one off, but the head came with it, and this
marshmallow fluff crap poured out the neckhole and smelled
so bad I thought I would puke.

Dude, that's NOT how you do it, you said.

You slipped a mirror between the halo and the head and it fell
away easily. We filled our bags with halos and left.

The bus driver wouldn't let us back on since we smelled like
angelpus. We had to walk all the way back to your house.

We spent the rest of the day dipping the halos in turpentine to clean them.

What are we going to do with these? I asked.

I dunno, you said.

YOU DON'T KNOW? I spent all day ankledeep in angelcorpse ruining a perfectly good pair of shoes and you don't know?

Hey, you said, I didn't tell you to wear your good shoes.

In the end, we made mobiles and hung them from the ceiling. By then it was late, and we were tired, so I crashed at your place, but when we turned off the lights, it was too bright to sleep.

My Date with Wonder Woman

After a long dry dating drought, I placed a personal ad:

Single white male, 33, seeks independent woman of action. Imagine a movie in which Pam Grier saves the day and gets the man in the end. You should be Pam Grier, and I will be that man. I will be your backseat betty as we ride off into the sunset on your Indian motorcycle.

So I waited. I heard from the polyamourous wiccan. Then from the satanic performance artist who was really into bloodplay. Then, the beautiful artschool girl who said my picture was hot and her boyfriend thought so too and wanted to have a threesome and that I should be willing to sign a release form for the digital video they would make of it.

I was about to cancel my account, give up completely, when I got in a response, from wwoman@justiceleague.com. *I think I'm the woman for you,* she said, *I'm of Greek descent but grew up in Brazil. I moved here as an adult, and, as I am very busy and very successful in my career, I don't have a lot of time to meet men.* Sounded good to me. I emailed her my number.

She called me. It sounded really noisy. *Are you calling from your car?* I asked. *No,* she said, *I'm calling from my plane. So you're on a flight and calling from that white phone attached to the seat? No,* she said, *it's my plane. I'm flying it. I use it for work. But we can talk about that later. I'll be in town tonight, let's go to dinner.*

When she showed up, I was stunned. She was built like a 1940's pinup model with this more innocent Betty Page kinda retro look. She ordered the steak, rare, and ate it casually while she regaled me with tales of adventure. We got along famously, and after dinner she invited me to her place for a nightcap.

So as she's making drinks, I'm checking out her library. Mostly books on criminal law and true crime. Not really my thing. Next to the books are pictures of runways and airport hangers with nothing else in them. *What's with these pictures*, I asked. *Those*, she said, *are my plane.* Then she laughed and said, *my plane is invisible.* I'm the only one who can see it.

There had to be something. I can't fall for a sane woman. I've put up with JFK conspiracy theorists, believers of fairies and elves, new agers who read auras, and girls who think Morrisey is singing about them, but never have I put up with an imaginary plane.

Look, Wanda, I said, *it's getting late, and I have to get going.*

It's not Wanda, she said, *oh, forget it.*

I'll call you, I said, turning for the door. But then I stopped, unable to move. I looked down. There was a rope around me. Wanda had lassoed me. She pulled me close. *You don't have to call me,* she hissed in my face. *Don't say you're going to call if you're not going to. You don't have to call me, the only thing you have to do is tell me the truth.*

Nascar & Nothingness

Elvis may or may not be dead,
But there's no doubt about Dale Earnhardt.

I had a girlfriend from New York.
She once referred to my family as rednecks.
"Don't call them that," I said.
"But you call them that," she replied.
"No, I call them hicks," I corrected.
"What's the difference?" she asked.
"Hicks go to church,
and won't laugh at a dirty joke
even if it's funny.
Rednecks go to honky tonks
and laugh at every dirty joke
even if they don't understand it."

She claimed it was a class difference,
but I tried to tell her it was a religious difference.

Hicks are religious;
Rednecks are spiritual.
In the religion of hicks,
they follow a strict set of rules
governing what they can or can't do.
In the spirtuality of rednecks,
no one can tell them what to do.
They will do what they want.

I know about both,
having been each one
at different times in my life.

When I stopped going to church
and started drinking whiskey

I changed from being a hick
to a redneck.

My family were hicks
but really close to rednecks.
For awhile
we raced stock cars
but never on Sunday.

My cousin, Rob,
and my Uncle Gene
used to run their cars on a mile dirttrack.

I used to stand in the pits
keeping time with a stopwatch.
The noise was so loud
I couldn't hear anything.
This is the first paradox
of car races.
I communicated with hand signals
to my Uncle, my cousin, my father,
and whoever else was there.
The rest of our lives washed away
and we became the keepers of the secret
that rednecks meditated to find.

The engines of our cars
were tuned to hum mantras as they passed the stands.
Om...om...om...

The rednecks
listened, watched, and slowly got fatter
like Buddhas drinking beer from plastic cups

Whereas the Gautama Buddha had a bo tree
to sit under endlessly
and wait for enlightenment
Rednecks have the couch

to sit on endlessly
holding the remote
like a lotus flower.
They may appear to be watching cable
but if you ask them what they are watching
they will say "nothing."
They are waiting for enlightenment.

When you watch
NASCAR on TV
and they show the cars together
relative to each other
they look as if they are standing still
when in fact they are moving at top speed.
This is the second paradox of car racing.

I had a girlfriend raised by hippie parents in California.
She had never been to the South before
until I took her to a family reunion.
She had been all over the world
except to the middle and southern parts
of her own country.
She broke up with me after a year
because we weren't moving forward
or going anywhere.

If you take the train out of San Francisco
to the Bay Point stop,
you can stand on the platform
and see the Midwest.
It starts there and continues until
the westernmost part of NYC's subway.
Between those two places,
according to Californians,
are farms, Chicago, and truckstops.
If you ask them who lives there,
usually they'll answer, "rednecks."
Their mind fills with images

of *The Beverly Hillbillies*
and the assrapers from the movie *Deliverance*.
Usually they've never been there
nor do they watch NASCAR.

People who never watch stock car racing
think they know why everyone else watches stock car racing.
This is the third paradox of car racing.

They will tell you the only reason people watch
is for the crashes,
and refuse to believe anything else.

When Dale Earnhardt died
Rednecks all over the country
cried as they hadn't cried
since Elvis was reported dead.

Any Redneck who wasn't already crying
started to at when they heard
Classic Rock stations
play "Freebird" in tribute.

I had a girlfriend from the San Fernando Valley
who had never heard a Lynyrd Skynyrd Song before.

When I left her,
I played the Skynyrd song "Tuesday's Gone"
every day for months
and cried like an Elvis fan at Graceland.

On some plane of reality
Dale Earnhardt drives around a track
for all eternity, forever turning left and
laughing at a dirty joke
he heard long ago
but just now understands.

Little Known Facts about Angels
or
How the Dinosaurs Really Died

I've seen angels
with wings too withered and small to ever have worked
like the extra legs on a sideshow calf.

I've seen angels
in public toilets
tying off with their own halos.

I've seen angels
burning off their wings feather by feather
one hit off the crack pipe at a time.

I've seen angels
with swollen halos, junksick
feeding me lies that tasted like honey.

Angels, like rabbits,
will scream if threatened.

Every time you lean back in a chair
and catch yourself before you fall,
an angel dies.
That feeling in the pit of your stomach
is the sound of the angel screaming.

Angels, like rabbits,
are commonly used in laboratory testing.

Hairspray is sprayed into their eyes
to measure the toxicity.
Angels in the control group
are not allowed to pray.

I've seen angels
with their wings clipped
scratching at phantom itches
in spots they wouldn't have been able to reach anyway.

I've seen angels
hocking their halos
in the pawnshops next to casinos in Vegas.
You can see the halos under glass
next to the wedding rings.

I've seen angels
paralyzed from the wings down
vainly trying to enter churches
that are not wheelchair accessible.

I've seen angels
arsoning bushes
trying to get a hold of
Halo Technical Support
but there's no customer service in heaven.

Most angels that fall from heaven
do not hit the earth.
Fallen angels hurtle through space at millions of miles per hour.
At night the sun's light reflects off the angels
and they resemble shooting stars.
This effect is called Angelicus Solaris.

The first angel that hit the earth
made a huge crater
and put so much dust in the air
that it changed the earth's climate
and that's how the dinosaurs died.

South Boston, North Hell

I was somewhere in Boston
getting my ass kicked by Catholics again,
hockey style,
where they pull your coat over your head
so your arms are stuck
while they hit you.

At that moment
I imagined
my friends in Arkansas
were getting drunk
losing their virginity
and wrecking hot rods
while I was taking a beating
for something I wouldn't even believe in
two years from then.

I had pissed off some Southie kids
by inviting them to church.
Everyone in our church
was supposed to ask strangers on the street
on a daily basis
to study the Bible with them.
Being fifteen years old, this kind of response
was all too common.

These kids liked to fight,
fistfighting either
like boxers
or hockey players.

When you've been beaten up enough times
your body learns how to go numb on the first hit.
After that you hear the punches

more so than feeling them.
It sounds like dribbling by yourself in a gym
cannon shot echoes
bouncing off the loneliness of your ribcage.

I was taking a beating
that would leave me with permanent hearing damage.

I was taking a beating for Jesus
turning the other cheek
the other eye
the other lip.

I was taking a beating
one in a series of many
and each time
I wanted to be anywhere else
but there was nothing I could do
except listen to the rhythmic pounding
and look down the long tunnel
of my coat.

All I could see
was a small circle
like a searchlight
showing me sidewalk
cigarette butts
and sneakers,
while I looked for some friendly piece of ground
I would never find.

My Girlfriend Is Way Cooler
than Wayne Gretzky's Helmet

My girlfriend is allergic to peanuts.
If I eat a Snickers bar
and kiss her
she could die.
If I had a venereal disease
and kissed her
she would be really, really pissed off.

My girlfriend will never know the ecstasy
that is a Peanut Buster Parfait,
unlike hockey legend Bobby Orr,
who eats as many as three of them a day.

Hockey legend Bobby Orr
hangs out at a Dairy Queen in Waltham, MA
with Gordie Howe and Eddie Shore.
Together, they act real stupid
and try to pick up girls.

When Wayne Gretzky retired,
Hockey legend Bobby Orr
called him and asked him
to come over and hang out.
But when Wayne Gretzky showed up
they took his helmet
and played keepaway with it
until he cried.

"Don't be such a baby,
stop your crying,"
said hockey legend Bobby Orr,
tossing the helmet back,
"We were just playing."

"I wasn't crying,"
said Wayne Gretzky,
turning to go home.
"I just have something in my eye."

But you can't fool
hockey legend Bobby Orr.
He knows when
you have something in your eye
and when you're crying.

Wayne Gretzky wears his helmet all the time.
Not because he plays hockey, but because
he is terrified of everything,
and the helmet makes him feel safe.
On the plane flight home from Waltham, MA
he held onto his helmet and cried
all the way home.

My girlfriend is not afraid of flying.
If she were in a plane crash,
there is a chance she would survive.
But if she ate the peanuts
that are the inflight snack,
she would die.

I have a recurring nightmare
that my girlfriend and I
are playing hockey,
and I hit her in the mouth with the puck.
But in the dream
instead of a puck
it's a Reese's Peanut Butter Cup
and I accidentally kill her.

Tragedy and Bourbon

Both of my grandfathers left me a gift upon dying.
One, a taste for hard liquor,
and the other,
a taste for tragic women.

When I go to bars,
one eye focuses on my drink
and the other
looks for a woman
who uses ghosts for hairspray
and bad memories for eyeliner.

While I listen to her stories,
I have time to drink.
(I know she will have stories.
Tragic women always do.
They are only looking for someone
who will listen.
When they run out of stories,
they break up with you.)

When I am heartbroken
my mother comes to me in dreams.
She says,
My child, I am sorry,
but you should know better by now.

I know, Mom, I know, I say,
but I couldn't help it.
She looked so sad over there
sitting by herself
drinking her cocktail
so full of stories
I could see the words coming out her pores.

What have I told you? she says.
There are only two types of men
that tragic women will go out with:
abusive men and listeners.

I know, Mom, I know.

And another thing:
stop drinking so much!
My mother's father
married a woman so mean
when she spoke
the snakes in the yard
slithered under the porch
afraid she would snatch them up
and bite them.

I look at pictures of him and his wife
see the scowl she wore
like a halo of dissatisfaction
and the look of contentedness
on his face.
I imagine he had a trick he never gave me
along with the gift,
maybe to have a short term memory
so you can listen to the stories
for the first time
over and over again.

When I am heartbroken
I turn to hard liquor.
The ghost of my whiskey grandfather drinks with me.
He says nothing,
stares ahead with his sour mash eyes,
and lifts his glass
with fingers that have calluses
in the shapes of
Jack Daniel's bottles
and unfiltered Camel cigarettes.

Sometimes it is better to drink with someone
who doesn't talk
especially when you've done something stupid
and don't want to talk about it.

Asphalt Matador

As I sang karaoke
in Japantown

You were thrashing about
on the highway.

Five Detroit bulls ran you down,
left you severed and dying.

You were a matador
matched against life's cruel tricks

With a cape made of
affection for the absurd

And a sword made of
acerbic wit.

We cheered you on
as you made us laugh at our own tragedies.

The day of your funeral
it seemed like the whole world had gone silent.

The crowd emptied the stadium wordless.
The great one was dead.

Black Ice and Roses

She brings me black ice and roses,
drinks whiskey and coke.
Sipping sweet toxic soda,
I can't give her what she wants,
so I just smile instead,
chipping away sobriety
with my bourbon icepick.

She won't believe me when I say
her time on me
is wasted.

Tonight, I am drinking
with the ghosts of drowned fishermen.
She can't hear them belch up seawater,
she can't smell the dead fish,
but she knows something is wrong.
She asks me what's wrong,
but, before I can answer,
she says, "Never mind,
I've got a full tank of gas,
let's go somewhere
and drink until we forget we ever went wrong."

Later.
The seat of her car
is covered with heartbreak vinyl.
I sit with the window down,
a bottle between my legs.

The end of my cigarette is a sunset
for the microscopic
or for those with low expectations.

I'm blowing smoke out the crack
feeling any words to be
just as meaningful as the exhale.

Black Spots

The first night I spent with her
she held me and
the black spots went away.
The black spots
that taunt me when I try to sleep
that tell me that
tonight's the night
they're all going to burst open and
I'm going to remember every bad thing I've ever done
tonight's the night
they're going to break free
from the mental prisons I shoved them in
the black spots
floated away like released balloons
went so far I couldn't see them.
She held me and
the black spots went away
I slept
and it felt right to have her there
I slept
and held her close to me.
She was the first person
I wanted to touch me when we slept together.
She was the first one who didn't leave when
she touched me at night
and felt the black spots burrowing underneath my skin.

She had scars
covering the inside of her forearms
(she was an ambidextrous cutter back in her mutilatory
prime).
She had scars
from when she wasn't good enough to die.
She had scars

from the punishments she meted out for herself.
She had scars
and I kissed them when we made love.
She had scars
all over
little ones here and there
and I found them all
with my mouth and my fingers
some were too pale to see
but when I touched her lightly enough
I could find them.
She had scars
that I only knew about in the dark.

She pushed me out of her life
slowly
tenderly almost
as if we were dancing.
She pushed me out of her life
slowly
so that I didn't notice it was happening at first
like watching the movements of hot lava.
She pushed me out of her life
and I might have black spots but
she had demons
and they were much stronger than I.
She had demons
and they helped her push me away.

When she was gone
the black spots returned.
They said
we will never leave you
not like she did
we will never leave you
we will visit you every night
and hover in your dreams like rainclouds
we will never leave you

but someday we will burst
and envelope you with your own regret.
When she was gone
a stiffening liquid cold
seeped between my joints
while I tried to sleep
and the only cover I had to pull around me
was a blanket of lies.

Frank's Depression

Frank's Depression
was one scary looking motherfucker.

Wasn't always that way.
When I met him, with his
combat boots
crazy hair
leather jacket
Peter Lorre eyes
New York accent
wasn't anything too unusual for a
San Francisco 1990 style punk rock motherfucker.

Frank was the machine gun of poets.
He could read you 30 poems in five minutes.

"My poems are short," he said,
"Because I don't know many words.
Didn't even know how to read
until a couple of years ago.
Taught myself to read with Henry Rollins' books."

Fortune cookie
word shank
icepick in the kidneys
30 poems in five minutes
in and out
stick it in motherfucker.

Frank started living the squat life.
Scabies and forties
all night cheap crank
penny hustling
anarchy and crowbars
chaos and copdodging motherfucker.

It all started to wear him down,
he lost a lot of teeth
no eyebrows,
looking like a flying monkey with its wings cut off
some kinda Grendel/Mad Max motherfucker.

Frank lived on a diet
of malt liquor and high octane attitude.
Got in a fight one night
with some bouncers in New York
They beat the crap out of him
and threw him out
into the night.
Frank,
drunken and beaten,
bloody and defeated,
found a door way to sleep in.

The next morning,
the cops came to kick him awake.

"Get up, motherfucker," the cop said,
"You can't sleep here.
Get the fuck up, motherfucker.
I said you can't sleep here."

Frank didn't move.

"Oh, fuck!" the cop said.
"We got a dead one here."

Garden of Gutted Beasts

The faroff mountains
crawl slowly across the landscape
like rats underneath a bed sheet
more slowly
than the hands of a clock
as you sit by the phone
and wait for a call
bearing the news of death.

I emerge from between my mother's legs
stretch myself out
and hold her on her deathbed.

She tells me her fears
and I tell her it is okay to die.

I leave the room
and in the next 36 hours,
obscenities, profanities, and curses
she has never before uttered
fly forth from her mouth
like the first black feathered angels
released from the pit of Abbadon.
She screams the lyrics
of a gospel record
she recorded in 1957
and it is over.

As I wait
for my hair to fall
my teeth to fall
and for myself to fall for the final time
pulled into the earth
by the unrelenting hand of gravity,

I stand in the garden,
among the corpses of gutted beasts,
who rot without shame or excuse.

I could not express my rage
if I were a field of flowers
with thousands of tiny petal fingers
clenched in tight budfists
swaying angrily at an uncaring moon.

The far off mountains
would think me insignificant
if they noticed me at all.

Home

Mother was too strong to die quickly.
Her mind blew out first.
She was still barely alive,
her mind running on fumes.

We didn't want her to die in the hospital
so we brought her home
fixed up her room
with a new bed and a morphine drip.

She called to me
and I came in from the West Coast
to be with her.
She had one last request:
"Take me home."

I can't take you home,
this is all that's left,
I'm sorry,
there's nowhere left to take you.

Across the hall,
my father slept in my old room.
It was full of
baseball cards
and hidden vodka pint bottles.

On the wall hung a bat
I played little league with.
On the wall hung a bat
that I kept in the trunk
of the car when I went out.
On the wall hung a bat
that I took to Memphis

when I looked for the man
who raped my cousin.
I wanted to bloody that bat up
I wanted to turn him into a collage
of busted kneecaps and broken teeth.
I looked all over Germantown that night
but couldn't find him.
That bat hung there on the wall
bloodless and clean.

Under the bed
were all my paintings and drawings
my parents were afraid to hang in the house.

I stayed downstairs in the basement
in a small room, the only room
where I couldn't hear my mother die.
The room had no windows
and only a mattress on the floor.
It was all I had left of home.

Home was the props department
of a movie of bad memories.
I had been trying to go home for years
but couldn't find it.
Home was not where I had been.
Home was not where I was.
Home was not anywhere I could go.

I shut the door and pulled the darkness close around me.

Home is a place you run from.
Home is a street you bled on.
Home is a bathroom stall
 you puked and passed out in
 and woke up without your shirt.
Home is the carpet
 that burned your elbows and knees
 the first time you had sex.

Home is the driveway with your handprints.
Home is the drywall with your knuckleprints.
Home is the tree you buried your cat under.
Home is the parking lot
 where your two am whiskey glass landed
 when you threw it at the moon.
Home is the dirt with the worms
 that crawl through the skull
 of your grandmother.
Home is the highway you got so lost on
 you thought you had found
 a rift in the space-time continuum.
Home is the bridge you ran out of gas on
 and waited for the blue eyed man
 with a chainsaw
 to give you a ride.
Home is the river whose black mud
 squished between your toes.
Home is your best friend's couch.
Home is the rooftop at midnight
 the sky blacker than a dead angel's eyes
 your patience shorter than an amputee hooker's stumps
 your life covered with a bad luck leprosy
 your regrets burning inside
 like a self immolating Buddhist monk protesting
 the kind of life and the love,
 the corners of your mind,
 the calls that you made,
 the calls that you missed,
 the quality of time
 and the quantity of kind words
 that you heard
 when you gave it all up

sold it all out

 cashed it all in
 for a pipe dream
 with more holes in it
 than a dead baby
 that's used as a lacrosse ball

and instead of lacrosse sticks
everyone plays with pitchforks,
and for some reason
you didn't jump.

Home and getting home have been the subject of thousands
of songs.
When my mother died,
she sang a song for her last words.
It was about going home in its own way.
I hope she found it.

A Million Bucks Crying on Her Front Porch

I was coming home
a little drunk
singing a song to myself
to cut the cold.

I turned to face my gate,
key out,
and saw a dark figure on the porch.

It startled me.
The porch light wasn't on,
I thought it might be
some freak sitting up there
getting high
waiting for me
or something.

"Oh, hi,"
the dark figure said,
getting up to let me in.

I could see her as she got closer
in the streetlight's glow.
She was one of my neighbors
from one of the downstairs flats.
She let me in.

"Locked out?" I asked.
(One of my roommates had gotten so drunk once
he couldn't work the front door locks
and passed out on the stoop.
This neighbor and her roommate
came home, saw him there,
and took him inside the house.

When he woke up,
he didn't know where he was,
made a quick break for it
and realized he was only downstairs.
We would be only happy
to repay our debt.)

"No, I'm not locked out," she said,
sitting back down.

It was then I noticed she was crying.
She was dressed up,
retro glamorous
to the nines,
like a woman
acting opposite Bogart
or acting in a Hitchcock movie:
tragic and troubled.

She looked like a million bucks
crying on her front porch.
Even with very little light,
her face seemed to catch it all
and reflect just enough
to show her teartracks.

"I'm not usually like this," she said.
She sounded embarrassed,
caught in the act.

"We're all like this," I replied.
"Only some more often than others.
You need an ear?"

"No," she said, "I'll be okay."

And I had no doubt that she would,
but when I got inside,

I said a little prayer to Ingrid Bergman
and Kim Novak
just to make sure.

One Way Ticket to Midnight

The clock on the dashboard read
9 minutes to midnight
but we were 10 minutes from the county line.
If we could make it to the package store before it closed,
we would be all right.

God damn it, he said, slamming his fist into the ceiling
God damn it we better make it.

We had a party to get back to, and they were expecting
a case of beer, a bottle of Kentucky Straight,
and a hell of a lot of beef jerky.

God damn it, he said
*If we don't make it we might as well just keep on going
I ain't showing back up there empty handed.
Maybe we'll just keep driving
until we hit California.
Maybe we'll see the ocean
in a few days.*

He reached over,
ejected the Led Zeppelin tape.

*Fuck these guys, you know,
what do they know about not being able to see the ocean?
They live on a fuckin island!
Find something more appropriate*

I looked around in his cassette suitcase
picked out the Heavy Metal soundtrack

IT'S A ONE WAY TICKET TO MIDNIGHT

You seen the ocean right?

yeah I seen it I said

what's it like man?

didn't appreciate it much, I said,
almost drowned actually

Shit, he said, *sorry, I forgot about that*

He slammed down the gas pedal.

IT'S A ONE WAY TICKET TO MIDNIGHT

this is more like it he said
we gonna make it I can feel it

We were cramming 10 minutes of seconds into 9 minutes
worth of clothes
seams straining buttons popping
but by god we were going to make those seconds fit
like pulling corset strings tighter

IT'S A ONE WAY TICKET TO MIDNIGHT

It came to me
that I was constantly in the right place
but always a minute short.
If I could make up for lost time
everything would work out for me
and I could get my life back
the way it was
get a new start
all the rage and the dissatisfaction would wash away
and a peace of mind
would wrap itself around me
like a warm Malibu tide

IT'S A ONE WAY TICKET TO MIDNIGHT

Hey man, he said,
hey man what you thinking about?

Sorry, I said, just
daydreaming.

I was out of the car before he came to a complete stop
up to the liquor store door
as the man turned the lock
and walked back to the counter.

Fuck me, fuck me!
I heard from the car.

I banged on the door.
The guy turned around,
looked at me funny,
unlocked the door.

I was in before he could change his mind
made my selections
took them to the counter
and he said

Remember the time you saved me?

Then I recognized him,
from junior high school,
when he was much smaller.
I had pulled some older kids off him
kept him from a beating.

yeah I said, that was a long time ago, huh?

yeah, he said, *but you saved me that time
and that's why I let you in late.*

I got back to the car
told my buddy
I got my minute back
and made up my mind:
I was going to California anyway
give that ocean a second chance.

Right Field

Hey batter batter batter hey batter batter batter

1979. I am standing in right field waiting for a ball that will
not be hit to me. In little league, right field is the best seat in
the house, but you have to stand in it. Baseball being a game
of outs and innings, not minutes and hours, there is an
indeterminate time for me to stand here. I stand and wait and
watch the game. I stand and wait and watch the crowd. The
seats are filled mostly with mothers, sisters, and brothers. The
empty seats are filled with fathers who never came home
from Viet Nam, with fathers too drunk to show, with fathers
working double time to pay off the double wide, with fathers
who do not know that on a little league field in Arkansas they
have children coming to the plate trying to win their approval
one base hit at a time.

No batter no batter no batter no batter

Dewey comes up to the plate. He's going to bunt. We all
know this. Dewey has to bunt. Dewey has no arms. Dewey
has two hands coming from his shoulders and a sense of self
determination that could bend the aluminum bat he's holding
to his chest. Dewey plays pitcher: in this level of little league,
we use a pitching machine that has a chute to drop the ball in.
Dewey leans over the plate. The ball is dropped into the
chute. Phoomp, ting, thump. The ball foul tips off the bat
and hits Dewey in the chest, knocking him to the ground.
The wind is knocked out of him, but he doesn't cry. He
never cries. Not when the other kids stick their arms inside
their shirtsleeves and sing the Flipper theme song. Not when
his father comes home drunk and beats him until he doesn't
"smell like Agent Orange" anymore. We've never seen Dewey
cry, and sometimes we wonder if he can. Dewey gets up and
leans over the plate again.

Swing batter batter batter batter swing

Ten years later I had long stopped stepping up to plates and got caught stepping up to a mirror with two foul lines. My parents take me to both a Christian Rehab clinic and the mental ward. Take our son we don't know him anymore, take our son we don't know him anymore. I'm fending off so many questions and accusations I don't have time to ask why they gave our pregnant mothers drugs and said it was safe, why they sprayed our fathers with defoliant and said it was safe, why they fed us Ritalin like it was fucking pez and said it was safe, why they were surprised that I liked drugs and violent music when they had turned us into a generation of children raised by prescription medication and tv dinners and why they thought the solutions to our problems was to lock us up with prescription medication and food somehow worse than tv dinners, and all I really want to say is mom, dad, don't you recognize me, it's me, the kid out in right field.

Shine

Lost, broke, and broken-hearted,
I came to San Francisco
a two time loser
of everything I had believed in.
I came to hide
among the wicked and the heathens
but instead
I found the beautiful people
who were a constellation in the city's nightlife.
They weren't celebrities,
would never be famous,
but they knew how to shine
how to take the beauty inside them
and radiate for all to see.
They took me in and took care of me,
called me cabs when I was too drunk,
took me home when I was drunk enough.

They were my angels in Babylon,
saviors in a city of sin,
my guides in a wilderness of decadence.

But, most importantly,
They taught me how to get
everything I never knew I wanted;
they taught me how to use all the damage
that had been done to me
how to use my contusions
to make something beautiful.

Ten years later,
many of them are gone.
Some of them moved away,

others went into seclusion,
and too many of them died.

When the beautiful people die,
I bury them with pride
because the rest of the world
will see it as:
"just another dead junkie"
"just another dead faggot"
"just another dead stripper."

When the beautiful people die
I bury them with pride
because the rest of the world
will say things like:
"He shouldn't have been there anyway."
"She should've known better."
"That's what you get when you pick that lifestyle."

When the beautiful people die,
I bury them with pride
because all too often
their families are embarrassed just to have been related.

When the beautiful people die,
I remember how they knew how to shine.
I try to summon a bit of their brilliance
and carry it with me.

When the beautiful people die,
I celebrate after I cry
for I was blessed with a presence
most were not lucky enough to know.

Scatter my ashes on Valencia St.
where I used to walk like a king
but now I walk as if in exile.

Scatter my ashes anywhere you saw me in this city
but don't let them take a flake of me
back to Arkansas or anywhere else
because if I had listened to them back there and stayed
right now I'd be plucking chickens
or assembling TV dinners
while waiting for the job at the Wal Mart Distribution Center
to come through
and my last thought
after I wrecked my truck
the Steve Miller tape on the stereo still playing "Take the
Money and Run"
the last thought through my Jack Daniel's soaked brain
would be "there had to be something more."

This is the city
where the beautiful people taught me
that it wasn't about finding something to live for
but about finding a way to love to be alive.

Know in your heart
I would be happier dead here
than alive in misery back south.
But until my fateful day,
whenever my beautiful people die
I will laugh with the wicked
I will cry with the heathens
and I will dance for my dead.

The Face Off

One of those nights
no one's around.
Even the pigeons and the rats
have something better to do,
someone to do it with.
I'm a long way from
where I need to be,
a walk where the only people I see
are the ones
who "got something" for me,
who need something from me.

spare a little change?
wanna buy a radio?
spare a cigarette?
you lookin'?
you holdin'?
what you got?
what you need?
what you lookin' at,
whitey?
Fuck you,
white devil motherfucker...

He's drunk
and bigger than I am,
misquoting Farrakahn
and gets no respect
from me
or the Nation of Islam
cuz his malt liquor breath
don't mix with his rhetoric.

I was writing on scrolls
in Ancient Kmet

while you were crawling around
on your hands and knees
in the caves of Europe...

He's drunk
and bigger than I am
fucked up young black man
rage filling his mouth like foam.

He's drunk
and bigger than I am,
looking to fuck me up
and walking by him is my crime.

He's drunk
and bigger than I am,
his words crackle empty
cellophane curses
thrown in my face.

He's drunk
and bigger than I am
If I show fear,
he'll make a move.
If I show my lack of respect,
he'll make a move.
If I stand here
keep my mouth shut
and look him in the eye,
I just might walk out of here.

He's drunk
and wants to fight.
It could be with me
or anybody.
He doesn't care
who I am,
what I say,

as long as he finds how
to get me in his way.

Still I gotta think
would it make a difference
if I were a black man, too?
If he was smaller than me?
If I was drunk?
If he knew me?
If I was with somebody?

He's
taller
bigger
madder
drunker

and I am waiting by a stoplight
that will not change.

I am cold
but do not
zip up my jacket.

I am scared
but do not walk away.

I am lonely
but this guy
does not want to make friends.

Somewhere else,
sometime else
It could've been different.
If it had been
me and him
getting drunk together
on my front porch,

maybe we would've had a good time
and he wouldn't be so pissed off right now,
and maybe I would have
someone to drink with
instead of heading to a bar by myself.

Hangover Eulogy

It's as simple as crossing the street sometimes,
unavoidable as bad weather.

You can
look into a child's eyes,
see his dirty hands
many years into the future
grown over with calluses
like the sole of a camel's foot,
imagine his desperate fingers around your neck
as he sits on your chest.
All you can do
is raise a hungover eyebrow
to meet the stare of the little killer
as his mother pulls him
away from you
closer to her.
Her skin: soft and stretched,
Your skin: barely able to contain yourself
as you sit on the sidewalk
and try to ignore the brightness.

It's as quick as a bursting aorta sometimes,
unexpected as soured milk.

On the back of your neck
you feel the wet nose
of a three legged dog
startling you
out of a reminiscent daydream,
causing you
to kick over your 40 oz'er
spilling rabid foam
from its brown-lipped frothing mouth

onto your pantleg
into your peeling leather shoe
as you sit in the park.
The moisture of the grass
seeps into your butt
as slowly as your sobriety slips away.
The dog is friendly and happy
but reminds you
of a horrible beast
who chewed through your throat in a dream.
The dog's owner calls it away
and apologizes
but offers no other consolation
as you walk to the store,
the wind cold as regret
on your backside.

It makes sense,
like a body pulled from the East River, sometimes
foreboding as a three a.m. phone call.

You give a quick glance at the inventory
of a junkie's sidewalk sale
and the familiarity of the objects is haunting.
From the nodding face of the seller
the features of a friend are conjured,
a genie emerging from a needle.
You buy the CD's of bands you saw together,
clench your lover's hand
and fear she is on the same path.
Ten minutes ago,
you had had plenty,
but you go home
and pour another,
from that moment onward
searching the evicted eyes of street people
for recognition of former tenants.

It's unrelenting as a tumor sometimes,
obnoxious as insomnia.

A funeral ends.
You go to someone's house with a group,
even have a good time,
but eventually you have to leave
alone.

It's as obvious as an oncoming train sometimes,
common as saying goodbye.

Cold War Christian

STEP RIGHT UP
HURRY HURRY HURRY
COME SEE
THE AMAZING INFLATABLE JESUS
AND HIS COLD WAR MARY MACHINE
YOU—WITH THE FACE—

who me

YES, YOU—
COME SEE
THE AMAZING INFLATABLE JESUS

I don't wanna see the jesus

WHATSA MATTER, BOY?
YOU SOME KINDA
COMMUNIST OR SUMPIN?

what's a communist

WHAT'S A COMMUNIST?
DON'T YOU KNOW NUTHIN?
A COMMUNIST IS SOMEONE
WHO DOESN'T BELIEVE IN GOD!

I've met a few bible smugglers:
missionaries risking imprisonment
sneaking bibles into what was then called
"The Iron Curtain Countries."
They had odometers for eyes
prematurely gray hair
kept ulcers for pets
and could lie for Jesus
while looking down the barrell of an AK47.

BOY, WHEN THE COMMIES COME
THEY'RE GOING TO PUT A GUN TO YOUR HEAD
AND ASK YOU TO RENOUNCE YOUR FAITH,
AND DO YOU KNOW WHAT YOU'RE GOING TO
SAY?

no

PULL THE TRIGGER!

A family down the street from me
adopted a Vietnamese boy in 1975.
He slept under his bed for six months.
That's what he was used to.
They adopted him for God.
They adopted him for country.
They adopted him because
they were the red white and crucified.

IT'S RIGHT THERE IN THE BIBLE, BOY—
THE COMMIES ARE GOING TO START WW3—
THEY'RE THE DEVIL'S MARIONETTES AND
THEY WANT TO RID THE EARTH OF GOD'S
COUNTRY.
AND YOU BELIEVE IN THE BIBLE, DON'T YA, BOY?

yeah

WELL GET ON IN THERE AND TAKE A LOOK!

amazing grace for spacious skies
that saved a wretch like me
for purple mountain majesties
I was blind but now I...

I went down to see my inflatable Jesus
I wanted to touch his ziplock wounds

141

I wanted to see the shroud Betsy Ross sewed for him
I wanted to ask if they ate apple pie at the last supper

I climbed the Washington Monument
to find my inflatable Jesus
I walked on water across the Delaware River
to find my inflatable Jesus
For forty days and forty nights
I wandered through the Library of Congress
until the Warren Commision appeared unto me
and I surpassed every temptation known
to Senator Joe McCarthy
to find my inflatable Jesus

When I got to my promised land
When I entered my Canaan
When I walked into the land flowing
with milk, honey and the American Dream
I found my inflatable Jesus
But they had filled him too full of lies
and he popped.

The First Thing You Learn in the Pysch Ward Is Where the Bathrooms Are

I was fifteen
the first time I was there:
visiting hours.
my friend Stevie
said the wrong thing in his psych eval
and got lockdowned by his parents.

He was in a session.
I went to piss,
asked a girl where the bathroom was.

First time here? she said

yeah I said

Men's room is this way she told me
I use it too
there are two kinds of chicks in here:
pukers and cutters.
Girls room is for the pukers;
cutters use the boys's room—
doesn't smell so bad

What's a cutter? I asked.

She held up her arms—
stitches across her wrists.
shoulda cut down, not across she said
I'll get it right next time.

That's a joke, she said.

I didn't know what to say.
Where's your bracelet?

She took my arms in her hands
turned them over
looked at my blank skin
back up at me, confused, asked, *pills?*

I'm just visiting, I said
I don't belong here.

She stared at me suspiciously
with eyes the same color green
they use for church basement walls.
I wanted to walk down into them
and lock them behind me.

She threw my arms down
walked away.
I pissed.
Stevie was ready.
I asked him about her.
Oh, her, she said, *she's crazy.*

Maybe she was.
She may have been the first one I fell for like that
but she definitely wasn't the last.

I'm a sucker for those girls with scars:
scars from falling down,
goodbye-cruel-world scars,
scars on wrists you can read like lines on palms,
and scars deep and raised that you can feel in the dark.

I see those poison ring eyes
and know somewhere she's got them.

There's a cigarette burn in my memory
where her name is supposed to be.
I never saw her again.
Hell, I don't even remember
what happened to Stevie.

He was a good friend.
I loved him.
but Stevie couldn't beat a psych eval
if his life depended on it
and for us back then,
it did.

Love Song

LOVE ME…
Again and again
it came from the radio
LOVE ME…
incessant and taunting
LOVE ME…
but he couldn't turn it off.
He was like a ventriloquist gone mad
unable to put his dummy in the trunk.
LOVE ME…
It screamed at him as he left the house.

He walked to the bar.
Winos and junkies
have boyfriends and girlfriends
but I ain't got shit,
he thought.

Still, he was depressed beyond suicide.
Futility of desire stuck in his soul
like a nail through a voodoo doll.

The wood of the bar
was real.
The stale stench of urine
wafting from the men's room
was real.
The bourbon in his glass
was real.
Everything else seemed
an elaborate con
he couldn't disprove.

He drank.
He tried to remember

how it had come to all this,
what had changed
since the driveway gravel
crunched under his feet
as he ran to his grandmother's arms.
He remembered
the cheese sandwiches and chocolate milk
she made for him.
He remembered
the choking gurgles
she made from her deathbed.
Everything since then was a blur,
but getting drunker by the glass
felt pretty damn real.

He didn't know how long
she had been sitting there.
She had a look on her face
like two thumbs were inside her skull
pushing on her eyeballs.
He could see they shared the same vengeance
when they drank.

He said *got a light*
He said *come here often*
He said *nice tattoo*
He said *I used to like this place*
He said *can I buy you a drink*
He said *can you unhook the vise from my skull*
He said *would you drop an anvil on me*
 put me out of my misery
He said *would you set me on fire*
 kick me out of a plane at midnight
 and let me burn like a fallen angel
 in the night sky?

She said *got a smoke*
She said *didn't I meet you at a party*
She said *is that real leather*

147

She said *you have a nice smile*
She said *can I buy you a drink*
She said *can you take the icepicks out of my stomach*
She said *would you take a hacksaw to my neck*
 put me out of my misery
She said *would you smear my naked body in chicken blood*
 feed me to stray pit bulls
 and let me be eaten, digested
 and shit into piles all over the city?

Later
at his apartment
the bed
was real
the darkness
was real
and she
was real

LOVE ME…
He heard again and again
but the next day
he couldn't remember
if it had been him, her, or the radio
or all three
in unison.

The Little Children Whom God Hated

I have a friend who calls me
and tells me about her bad dreams.

We were the little children
whom God hated.
To get him back
we stopped believing in him.

(It's the only way to upset
an omnipotent being
that feeds on faith.)

Then the Devil got nervous
Figured he was next in line
so he sneaked up on me
shackled a nasty nightmare to my neck
grabbed me, held me close to him
and hissed,
"You can stop believing in heaven
anytime you want,
but it will take a whole lot longer
to stop believing in hell."

My friend and I
stopped calling them nightmares
and just call them dreams now
we expect them to be bad
and even though there's nothing
we can do or say
to make them go away
the calls are better
than the pills or therapy
that never worked either.

The little children whom god hated
we gather on the playground
where angels fear to fall,
we run phonograph needles across our arms
and listen to the sounds our scars make,
we hold hands so no one
will see us shaking.

Once
I saved my dreams
in a jar under my bed
for a week.
The next time the Devil
came to my house,
I wrestled him to the ground
held his nose shut
and made him drink the whole thing.

When I let him up
he puked
and his eyes watered.

I said,
"See, not so funny NOW,
is it motherfucker?"

Joker & Junior

During the trailers of the matinee, Joker flips the arm rest up and pulls in close to me. She talks, loudly at first, a tone quieter with each trailer.

I call her Joker for obvious reasons, but I can't always tell when she's kidding. Her setups are always deadpan and plausible, but her punchlines are absurd.

I stayed awake all night, she said. What, you couldn't sleep? I asked, afraid my snoring had kept her up. *No,* she said, *I was reading Irish folk tales to your cyst all night. We don't want Junior to fall behind the other cysts.*

Junior is a dermoid cyst growing subcutaneously on my scalp. We're pretty sure that's what he is. I have an appointment with the dermatologist next week to find out what it is for sure.

If it's a dermoid cyst, it's been there since I was a fetus. Then, it was speck sized and grew as a result of static in the DNA transmission. Every so often it can grow whatever kind of tissue it pleases: hair, teeth, or fingernails. I'm hoping for a tiny eyeball and a tooth, preferably a molar.

The first time I noticed it, I was about four or five years old. I was riding shotgun while my mother drove down a country road. Mom, I said, there's a bump on my head. It's nothing, she said, don't worry about it. That was the last I ever spoke of it to her.

Eleven years ago, Sick Girl noticed it. *What is that?* she asked. It's nothing, I said, don't worry about it. But Sick Girl knows everything that can go wrong with someone. Sick Girl speaks casually of obscure diseases like a grandmother naming

relatives no one has ever met. Sick Girl told me diagnoses like they were ghost stories. *Benign follicle cancer. Scalpus Gargantuae. Subcutaneous conjoined twin misoplexia.* Stop, stop, stop, I said. Sick Girl smiled, then her eyes got big as she said, *I think that mole on your neck has gotten bigger.*

Over the years, I've imagined it as everything from tumor to a homing device implanted as part of a global conspiracy. What if it's a nightmare machine? That little lump cranks out endless devil dogs to chase me in my sleep if I remove it I'll dream a test pattern? Or what if it's my good luck charm, a guardian cyst? What if it's a reset button, when I lose a life, I restart at the previous day with no memory of my death?

My primary care physician winced when she saw it. She didn't know what it was, but set me up with a dermatologist who would remove it. I wanted to ask her if I would have post partum depression. I wanted to ask her if Joker would still love me once it was gone.

The lights dim as the last trailer plays. Joker says in a whisper, *When they take it out, I'm going to keep it.* I wait for the punchline, but this time, I know she's serious.

The House That Punk Built

All I wanted
was a place to drink
a room to spin me to sleep at night
I wanted to drink
until I forgot how to pray

It had been 15 years
since I stopped believing in god
but upon waking
I still reached for the bible next to the bed
long after it was gone.
I couldn't stop reaching for it so
I put a bottle of whiskey
where the bible used to be.
For the next 15 years,
when I woke in fear of the wrath of god,
there was the whiskey to rock me to sleep,
my golden angel with liquid wings.
It had been 15 years since I lost god
and 15 years minus five days
that I found whiskey.

I found my home
in a house with hot and cold running punks
the ones upstairs
on speed and coke,
the ones downstairs
on vicadin and pot,
and the floor in the middle flat
had the drunken redneck shaped couch
that fit me perfectly

the flat was desolate and empty
quiet enough to die with the stolen cable on
all I had to do was drink and sleep

and wait
but your dog
your broken car alarm of a mutt
upstairs just couldn't keep quiet.

Dying is one of those things
other people make look easy
effortless
like ballet dancers
jumping into each other's arms
I thought I could jete
into the afterlife
from the couch that smelled like someone already had.

Each night I'd pass out
dream of lights at the end of tunnels
all kinds of symbolic shit
felt like it was coming
all I had to do was slide away

then your god damned dog started barking and pulled me
back.

Finally I decided it was time to head upstairs and meet this
mutt.

it was all fur and fangs
and so were you.

we yelled at each other
while your dog barked in anti harmony

it was hate at first sight.

Some people
you know right away you're going to be friends with
Some people
you can tell in the first fifteen minutes of talking
that you're going to hook up

And others
you never see them coming into your life at all
until they're there
and you're looking back on years of friendship.

People like us
We have a way of finding each other.

all of us
last chance players
thrown out children
coughed up and spit out
of some small town throat

We hold on to each other

Meanwhile my drinking plan wasn't working very well.
my kidneys liver guts all hurt
I could feel their outlines
Watching TV was hard
Lying on the couch uncomfortable
and walking clumsy

That's not a hangover, is it, you said
watching me walk across the backyard with the grace of
Frankenstein.

you can't fool an ex junkie you said,
I can tell there's something wrong in there

I knew I had three options:
 quit
die really slow and painfully
or help my body die some other way

If you want to quit you told me,
you have to leave this house.
you can't get sober here.

I left.
Found a place across the Bay
took up a diet of Vitasoy, V8, and Ben & Jerry's.
When the whiskey hurts hit me
I ate entire cans of sweet corn,
it's methadone for bourbon drinkers.

back at the house that punk built
someone left some strep germs on the house bong.
Everyone got strep throat
but your system was ravaged from your years as a junky.

They got better
but you never did.

I was in the gym locker room
when they called me on my cell
to tell me you had just died in the hospital.
I didn't know what to do
so I went upstairs and hit the weights
trying not to cry
not because people would see
but because I would drop the weights on my neck.

This song
this obnoxious pervasive pop hit
came on over the speakers,
it was no coincidence, they played it once an hour,
Every rep every lift I knew I'd always associate you
with this shitty Jimmy Meets World sappy piece of shit,
why couldn't I be at a heavy metal gym
so I could at least associate you with a song you liked.

I tried to stay sober,
gave up after your funeral,
got drunk one last time,
and sent you my last blackout as a gift.

I went to visit my neighbors' new baby
too young to talk
with more sober time than me.
soon she'll learn words
whose meanings start simply
but evolve into complexities
words like love, home, and friend
words we can draw pictures of when we're children

this life that we begin with a scream
we end with a whisper
inbetween we gradually lose
the ability to say these simple words to each other

I miss you like whiskey
I miss you like prayer
and when I wake in fear of the wrath of god
you are the only angel I have

about the author

Bucky Sinister found his love for poetry in the punk and performance art scenes of the late '80s. From 1991 to 1997, he ran the outrageous poetry brawl at the Chameleon in San Francisco. In 1995, Manic D Press issued his first full length collection, *King of the Roadkills*. His poetry was included in the *Outlaw Bible of American Poetry*. He has performed his poetry all over the country.

ALSO AVAILABLE FROM GORSKY PRESS

THE UNDERCARDS by James Jay paperback — 100 pgs.
"This book puts the smack-down on poetry!"
 —Jim Simmerman, author of Kingdom Come

PUNCH AND PIE ed. by Felizon Vidad and Todd Taylor paperback — 160 pgs.
"These stories are great. The corporate publishing overlords could never put out an
 anthology such as this."
 —The Iconoclast

BORN TO ROCK by Todd Taylor paperback — 318 pgs.
"When Todd Taylor graces our pages, we believe in punk rock again. And punk rock
gives us hope."
 —Ryan Henry, Thrasher

GLUE AND INK REBELLION by Sean Carswell paperback — 130 pgs.
"An almost flawless collection of pure literary entertainment on the most down-to-earth,
real level you could ever hope to find."
 —Jay Unidos, Maximum Rocknroll

THE SNAKE PIT BOOK by Ben Snakepit paperback — 304 pgs.
"Ben Snakepit captures some moments and moods of our lives so well, like a great song,
 and when it came down to it, I couldn't resist singing along."
 —Aaron Cometbus

GURU CIGARETTES by Patricia Geary paperback — 256 pgs.
"Patricia Geary is one of the best fantasy writers working."
 —Tim Powers, author of Last Call

BARNEY'S CREW by Sean Carswell paperback — 237 pgs.
"Sean Carswell is a wonderful storyteller.."
 —*Howard Zinn, author of* A People's History of the United States

BIG LONESOME by Jim Ruland paperback — 192 pgs.
"These stories gleam with witty mischief and an abundance of heart."
 —Mark Sarvas, The Elegant Variation

GRRRL by Jennifer Whiteford paperback — 240 pgs.
"The novel is full of pain, laughter, music, and life."
 —John W. MacDonald, Ottawa Citizen